WINCHESTER
HISTORY TOUR

First published 2016

Amberley Publishing
The Hill, Stroud,
Gloucestershire, GL5 4EP
www.amberley-books.com

Copyright © Anne-Louise Barton, 2016
Map contains Ordnance Survey data
© Crown copyright and database right
[2016]

The right of Anne-Louise Barton to be
identified as the Author of this work
has been asserted in accordance with
the Copyrights, Designs and Patents
Act 1988.

ISBN 978 1 4456 5693 9 (print)
ISBN 978 1 4456 5694 6 (ebook)

British Library Cataloguing in
Publication Data.
A catalogue record for this book is
available from the British Library.

Typesetting by Amberley Publishing.
Printed in Great Britain.

INTRODUCTION

Living in a city for many years, walking along the same streets and passing familiar buildings, it is easy to forget just how much history surrounds us. from the time of its Iron Age settlemnets, rulers, bishops and inhabitants over the last two millenia have left their mark on Winchester. Anglo-Saxon street plans, medieval gateways and castles still preside, as do buildings of religious and scholarly importance. It is this history, tinged with myths and legends and tales of our most celebrated monarch King Alfred which attracts people from all around the world. I have often envied visitors their time here in Winchester, and thought how satisfying it would be to see and photograph things for the first time.

While so much history still remains here, there have been many social and architectural changes. in the past forty years or so these have included those that benefit shoppers, such as pedestrianisation of the High Street and a new shopping centre. Developments in housing for both the general and ever increasing student population. Education has becom important contributors to the city's prosperity and cultural life.

Winchester escaped damage from the First and Second World Wars, with only one incident of bombs falling at the southern end of Hyde Street. The second half of the nineteenth century saw hotels, inns and businesses flourish following the arrival of the railway;

Winchester station opened in 1839 following the completion of the line from Southampton. Trains ran from London to Basingstoke and a year later the section between Basingstoke and Winchester was complete, linking the capital with the South Coast.

Winchester had plenty to offer both residents and visitors, and day trippers were now able to make the journey. The population had already increased as more efficient agricultural methods drove workers from the countryside to the city. In the 1841 census it was recorded at 10,732 and by 1881 it was around 19,000. Residential areas spread outwards, with large private properties reflecting a prosperous Victorian society. To the south the village of St Cross was absorbed, and to the north the village of Weeke.

In 1875 a new pumping station opened in Garnier Road, which overcame the problems of sewage disposal that had plagued the city for years. Winchester became healthier, hotels advertised 'modern sanitation' and the chemist Hunt & Co., then at No. 45 High Street, advertised 'High-class mineral waters and foreign mineral waters.' Photography was an exciting commercial venture and several photographers worked from studios in the city. Guidebooks were illustrated with photographs for the first time and postcards were sent all over the country and abroad, giving people the chance to show Winchester to family and friends for the first time. Many of these postcards feature in this book.

Winchester's history of course goes back much further, but it is the past 120 years or so that is focused on through these postcards and photographs. *Winchester History Tour* takes you on a journey throughout the city highlighting the many places that have changed over time or have changed very little. There were many more images that I wanted to use, and it was with much reluctance that I couldn't include them all.

ACKNOWLEDGEMENTS

I am most grateful to the following people for allowing me to use postcards from their collections: David Fry, Steve and Jenny Jarvis, Graham MacKay, Edward Roberts and Sandra Roll. Several photographs are from the Derek Dine Collection (70A09), held at the Hampshire Records Office. Further images are reproduced from original Francis Frith postcards by permission of the Francis Frith Collection.

Last but not least I thank my father, John Barton, not only for the use of his postcards, but most importantly his invaluable editorial assistance and local knowledge.

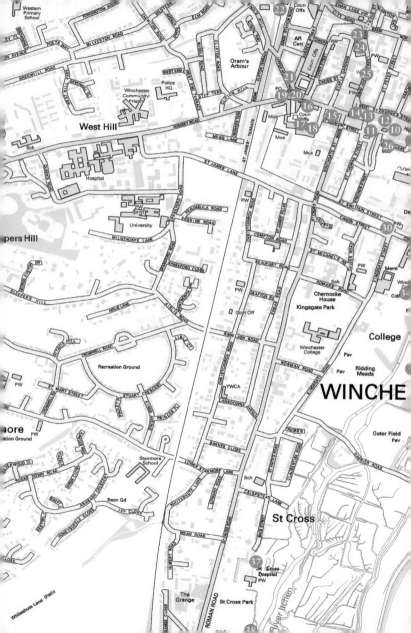

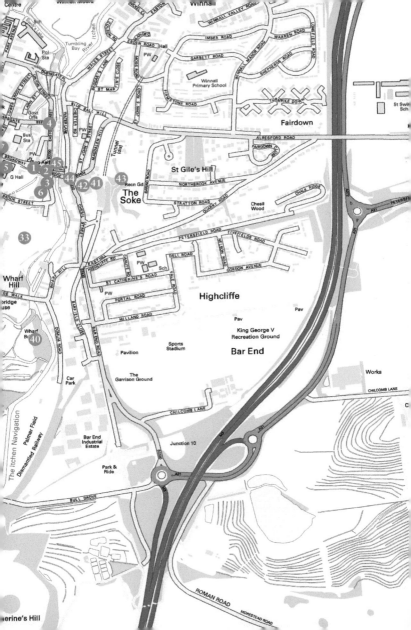

1. KING ALFRED'S STATUE

King Alfred was crowned King of Wessex in AD 871, making Winchester his capital. To mark the millenary of his death in 1901 (although it was later known that he died in AD 899) crowds of hundreds showed up to see the unveiling of the bronze statue, and the day was declared a public holiday. Visitors to Winchester arriving by coach are greeted by this impressive city landmark.

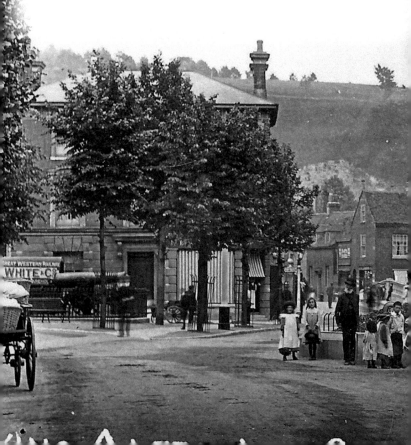

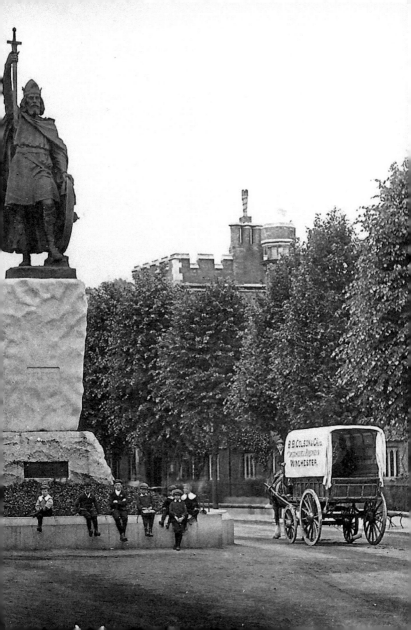

2. BRIDGE STREET FROM BROADWAY

A typical street scene of around 1930 with both horse-drawn carriage and motor car. The Great Western Hotel on the right was built in 1892, seven years after the Didcot, Newbury and Southampton railway line opened. The signs advertise 'cars for hire' and 'billiards'. After many name changes, this is now the Bishop on the Bridge (named after St Swithun). On the left is the Eastgate Restaurant which opened in 1926. There is now a row of shops between this building and the bridge.

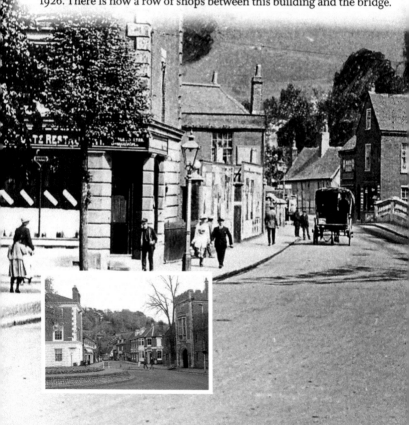

3. ST JOHN'S HOSPITAL, BROADWAY

One of the oldest charitable institutions in the country, originally founded by St Brinstan, Bishop of Winchester, around AD 931–34. The first reference appears in the late thirteenth century with the endowment by John Devenish of the chapel in the Broadway, which was dedicated to St John the Baptist. The hospital adopted the name and gave support to the old and infirm, needy travellers and the poor of the city. Today the charity is the largest independent provider of care for older people in Winchester.

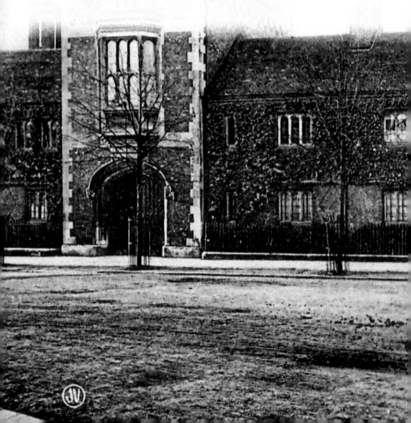

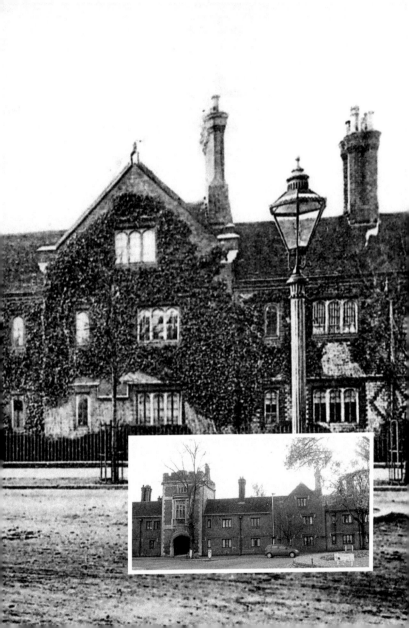

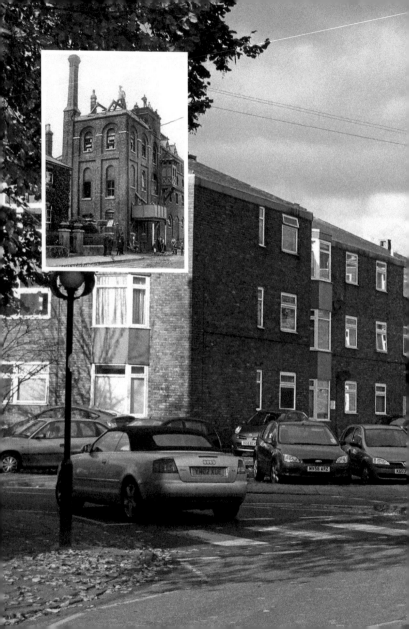

4. EASTGATE STREET

The Lion Brewery was one of several breweries operating in Winchester at the beginning of the twentieth century; others could be found in Chesil Street, the corner of Southgate Street and St James' Lane, and Hyde Street. Brewing ceased at the Lion Brewery in 1931 and in 1933 the Winchester & District Co-operative Society acquired the building for their bakery. The building was demolished in the early 1960s and the Greyfriars flats built in its place.

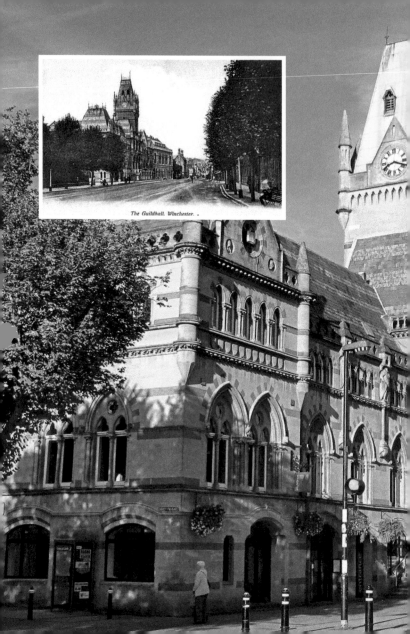

The Guildhall, Winchester.

5. GUILDHALL

Opened in 1873 at a cost of £10,000, the Guildhall contained the city council chambers, magistrates' court, museum, police station and fire station. If that wasn't enough, in 1876 the West Wing was added, which housed the School of Art, library and reading room. It recently underwent renovation of its rooms and continues to play host to various civic events, weddings and banquets. The ground floor also houses the tourist office and the new Eighteen71 café – the date the first foundation stone was laid.

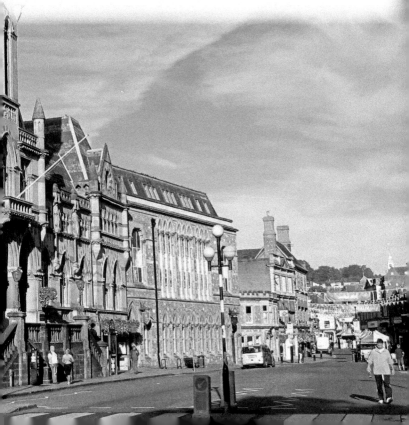

6. ABBEY HOUSE AND GARDENS

On the site of the tenth-century Nunnaminster begun by Alswitha, King Alfred's queen, these attractive gardens were opened to the public in 1890. The classical portico at the end of the stream hides the old mill, once part of the nunnery. Abbey House, built in 1751, is the official residence of the mayor.

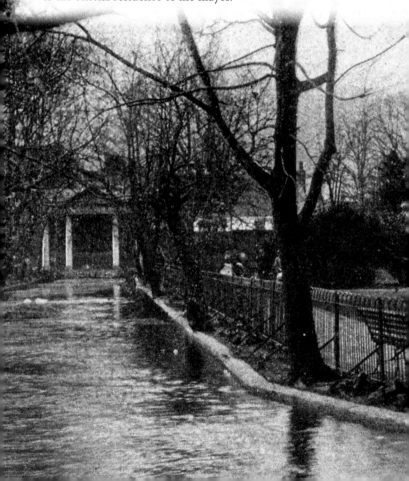

7. NO. 155 HIGH STREET

In his 1895 history of Winchester, Alderman Thomas Stopher stated that the occupier of No. 155 High Street, a baker named Henry Butcher, established the first Turkish Baths. Mrs Butcher attended the women's sessions. The last directory entry was for 1881, but by 1884 it had been taken over by A. Dumper, who already owned several shops in the High Street. The property at No. 155 is still attending to health requirements in the form of Lloyds Pharmacy.

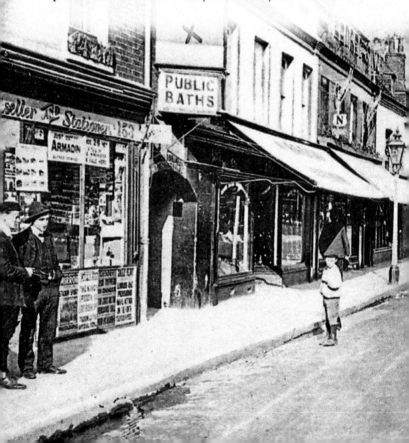

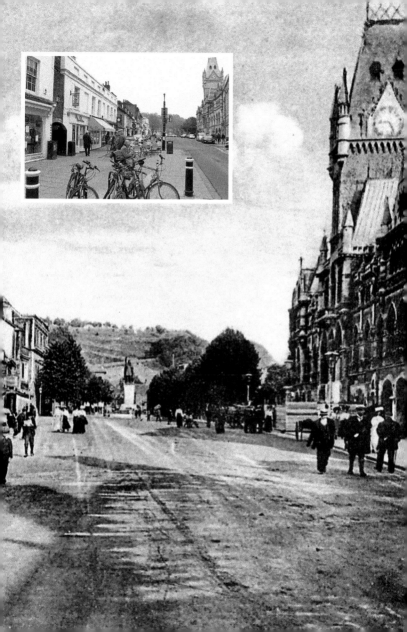

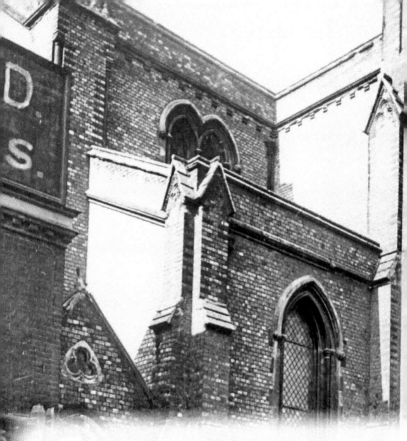

8. ST MAURICE'S COVERT

Originally backing onto the cathedral grounds, St Maurice's was a church of medieval origin. It was rebuilt in 1842 but retained and incorporated the tower and its Norman doorway. The only surviving parts to be found under St Maurice's Covert are in the covered area next to Debenhams (*inset*) which is a regular spot for charity stalls. The church was demolished in 1957.

2079 ST MAURICE CHUR

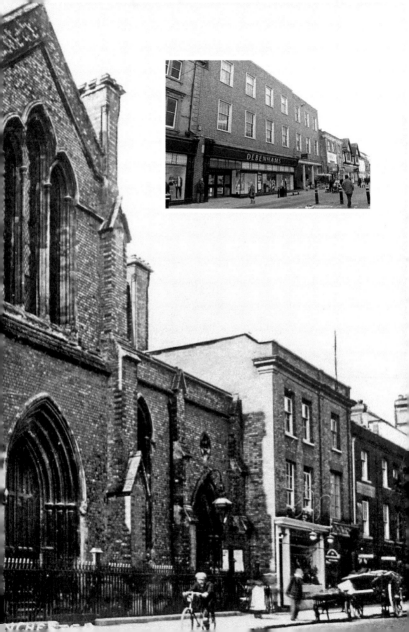

9. THE PENTICE

A need for shops to expand but not encroach on the road led to the upper floors of these sixteenth-century buildings being extended. For a time it was also known as the King's Mint after the thirteenth-century Royal Mint that had existed here. It was also known as the Piazza, as this early photograph shows. In 1903 Boots the chemists purchased their property from Gudgeon & Sons for £4,150.

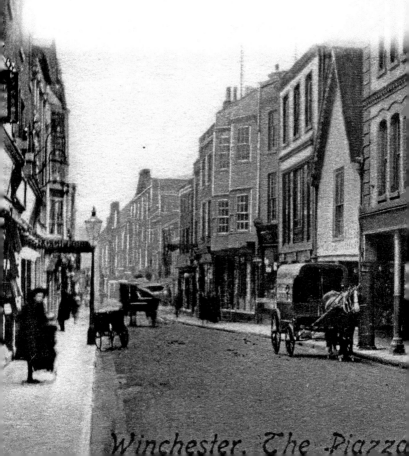

Winchester. The Piazza

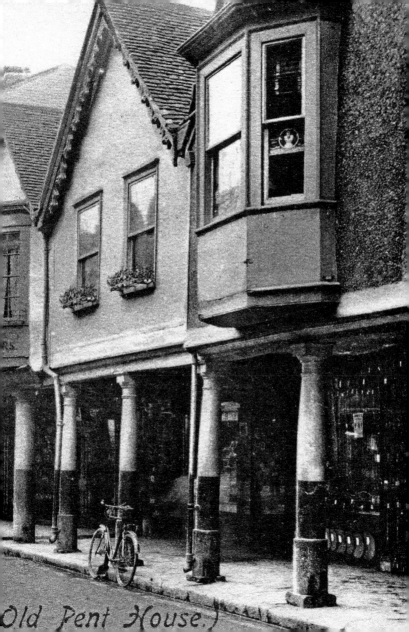

Old Pent House.)

10. BUTTERCROSS

This fifteenth-century High Cross was saved from removal in 1770 by angry citizens, after hearing that a wealthy landowner fancied it as a garden ornament. In the nineteenth century it was in danger of demolition but once again there was opposition, and fortunately it underwent restoration instead. In the same century it became known as the Buttercross when a dairy market was held in the area.

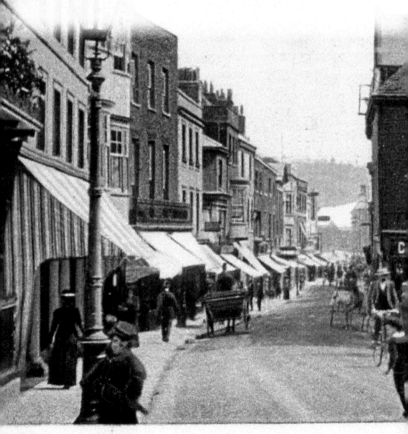

Winchester. High S

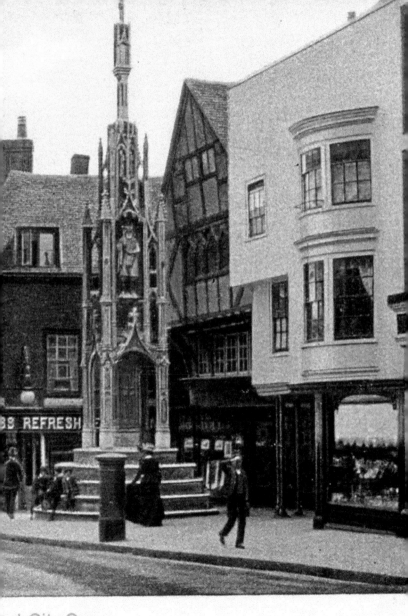

nd City Cross.

11. LLOYDS BANK

This building was the original Guildhall, used from the reign of Edward IV to James II, after which it fell into decay. It was rebuilt in 1713 after a visit by Queen Anne, and it was at this time that the great bracket clock – of which the present one is a replica – was added. A few shops down from Lloyds, at No.45 High Street, was Hunt & Co., a chemist since 1861 – the shop is now on display in the City Museum.

12. GOD BEGOT HOUSE

This historic building stands on the site of the God Begot Manor which Queen Emma, widow of King Canute, bequeathed to St Swithun's priory in 1052. The present building dates from the mid-sixteenth century, and although the exterior timber was added in 1908, much of the interior woodwork is original. Over the last 100 years it has kept visitors and residents well rested and well fed through its changes of ownership; it has been a hotel, a tea room and is now a restaurant.

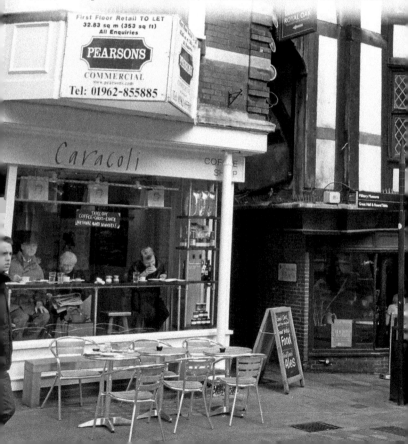

13. ALWARENE STREET

Between 1160 and 1290 a Jewish community was established in Winchester and the eastern boundary was the old Alwarene Street, the passageway that now runs between the God Begot House and the Royal Oak pub. The pub was built in 1630, and became known by its name soon after the Civil War, and this cobbled alleyway is now known as the Royal Oak Passage.

Side View of Ye Olde Host

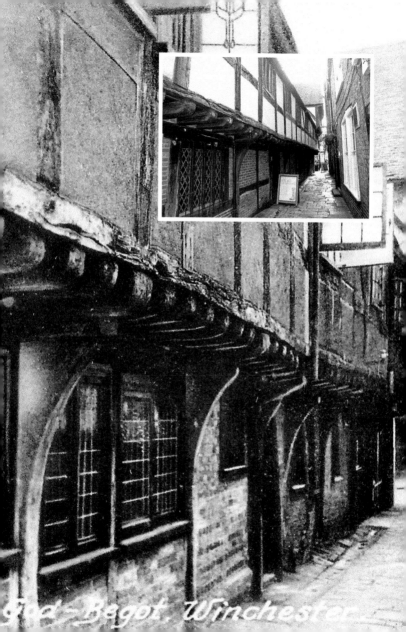

God-Begot, Winchester

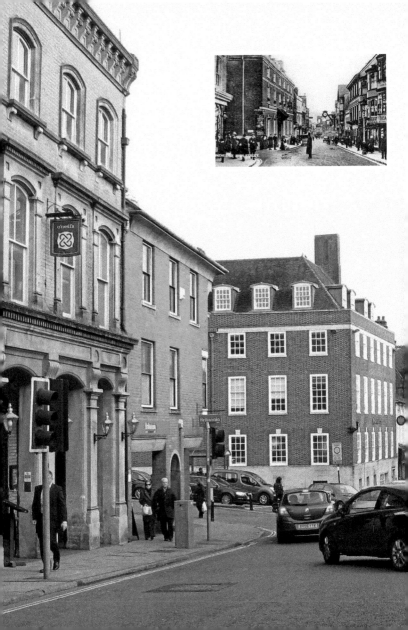

14. JUNCTION OF SOUTHGATE STREET, HIGH STREET AND JEWRY STREET

This busy intersection was controlled by a point duty policeman until 1934 when traffic lights were installed. At this time all London to Southampton traffic passed through Winchester until the bypass was constructed in 1938, but the continual increase in traffic led to the road eventually being widened. The George Hotel that had stood on the corner was sacrificed and Barclays opened in 1957. In 1974 the High Street was pedestrianised between Market Street and St Thomas Street, diverting the flow of traffic up St George's Street or along Jewry Street.

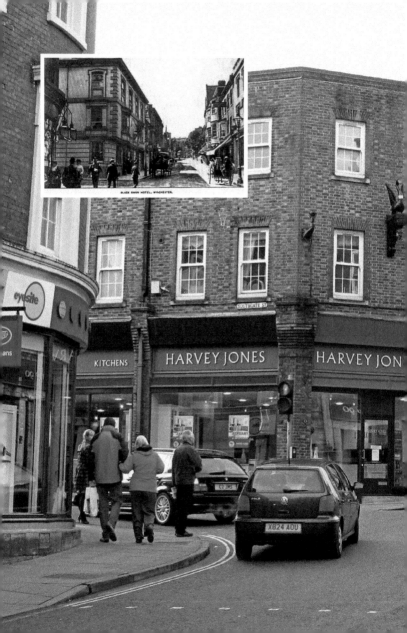

BLACK SWAN HOTEL, WINCHESTER.

eyesite

KITCHENS HARVEY JONES HARVEY JON

NORTHGATE ST

15. BLACK SWAN BUILDINGS, SOUTHGATE STREET

The Black Swan Hotel featured in *The Adventure of the Copper Beeches* where Sherlock Holmes met Miss Hunter. A keen photographer, Arthur Conan Doyle may well have stayed at the hotel for its advertised photographic darkroom facilities. Sadly the building was demolished in the 1930s, but the block of properties on this corner is collectively known as Black Swan Buildings. A replica of the original Black Swan statue hangs on the corner.

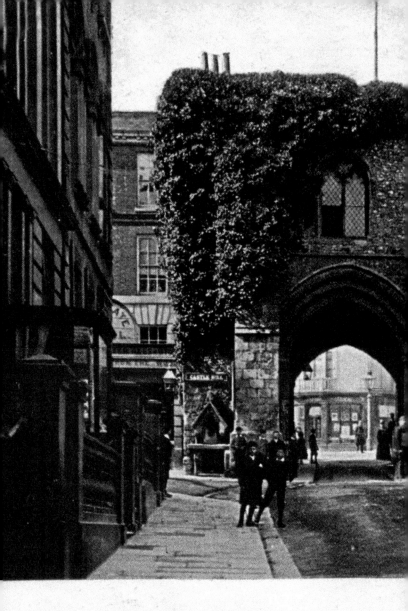

T GATE, WINCHESTER.

16. THE WEST GATE

The impressive fortified West Gate stands at the upper end of the High Street. Built on the site of the original Roman gate, the current stone dates back to the thirteenth century. It served as a debtors' prison for 150 years, a clubroom for the Plume of Feathers pub and now houses a small but interesting museum. The top affords fine views over the High Street to St Giles Hill.

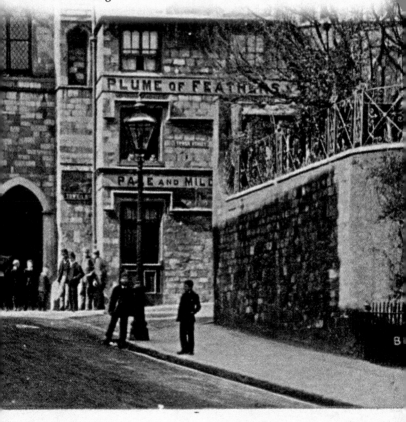

17. THE GREAT HALL

William the Conqueror's castle was rebuilt during the reign of Henry III, who added the Great Hall which is now the only surviving building, the castle having been demolished after the Civil War. The castle site has been the home of the Hampshire County Council since 1889, and whose offices adjoin the Great Hall. It has long been a site for justice too; before the current Law Courts were opened in the 1970s, the Great Hall saw the trial of Sir Walter Raleigh in 1603, who was condemned to death for treason.

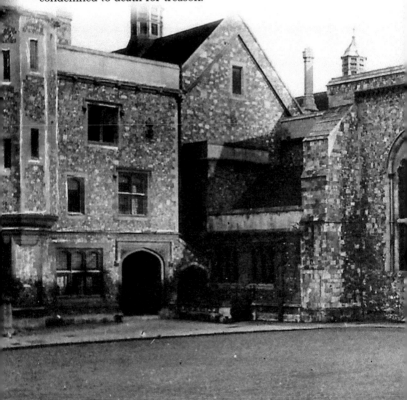

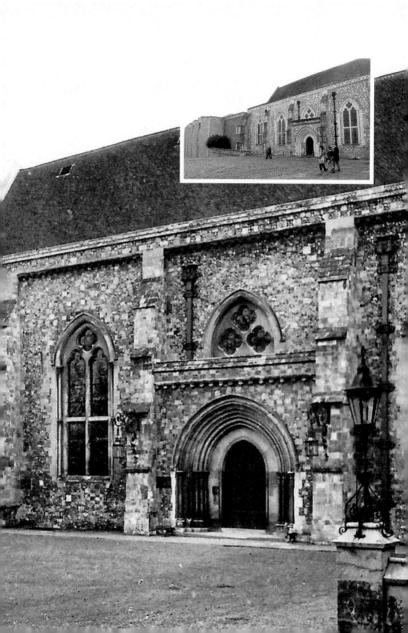

18. INSIDE THE GREAT HALL

Painted with the names of the legendary King Arthur and his twenty-four knights, this famous table has hung on the wall of the Great Wall since 1540, possibly as early as 1348. Since carbon dating the English Oak in the 1970s we now know that it originated around the end of the thirteenth century, possibly for a tournament Edward I held near Winchester in 1290, the King being an Arthurian enthusiast. During the reign of Henry VIII it was repainted to display the Tudor Rose at its centre. It is also thought to portray Henry as King Arthur on his throne.

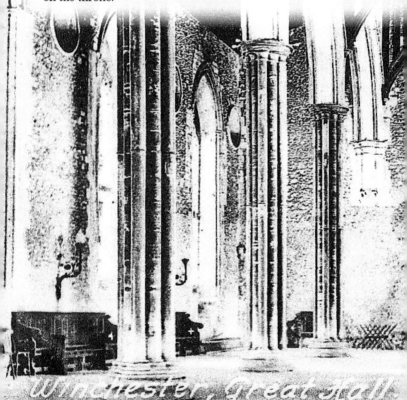

Winchester, Great Hall

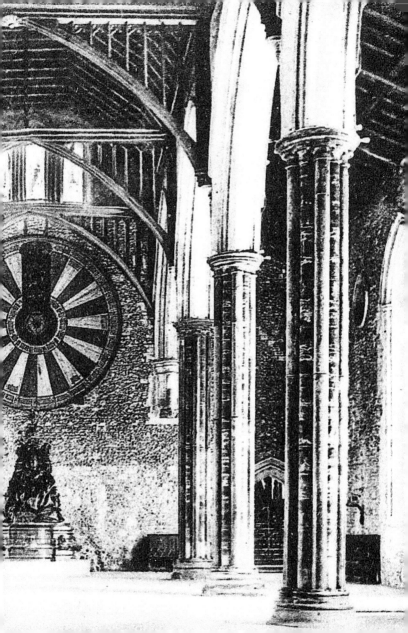

19. THE PENINSULA BARRACKS

These present-day buildings were built on the site of the King's House, which was built for Charles II. After the monarch's death it became neglected and was converted into barracks in 1796. It became the home of the King's Royal Rifle Corps in 1858 but was destroyed by fire in 1894 and troops were moved to Gosport while the barracks were rebuilt. In 1986 Flowerdown on the Andover Road took over as the training depot, and in 1994 the Romsey Road site was developed for residential use and renamed Peninsula Square. The site houses five military museums.

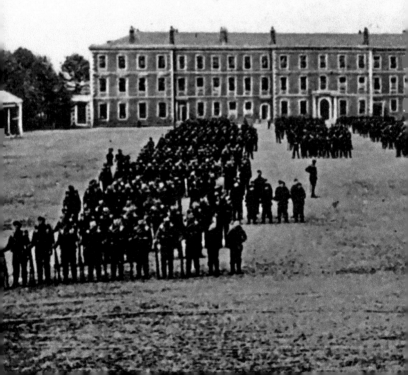

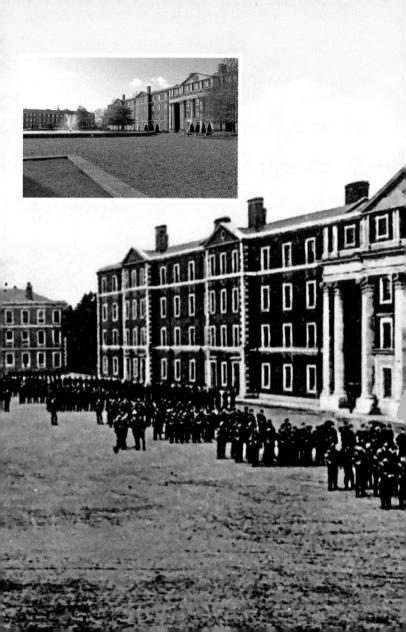

20. UPPER HIGH STREET

The drinking fountain was erected by Lancelot Littlehales in 1880 but later moved the short distance to Oram's Arbour in 1935 to make way for a traffic island. Provision of public water supplies by private donation was not uncommon. Another example of this is the horse trough in Jewry Street, a memorial to those animals that died in the Boer War.

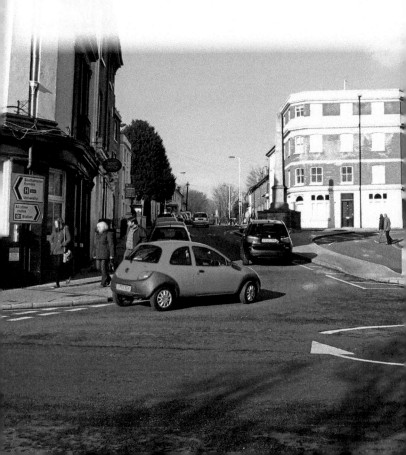

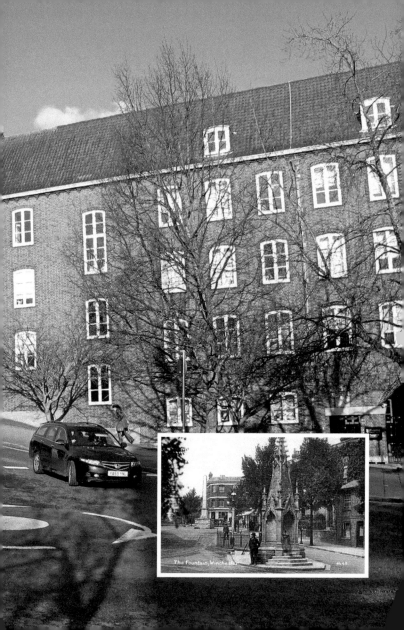

The Fountain, Winchester

21. THE PLAGUE MONUMENT

The Plague Monument was erected in 1759 by the Society of Natives to mark the spot where money was exchanged for goods at the time of the 1665 plague. People brought their produce to this point outside the West Gate and waited (at a distance) for the townsfolk to bring out their payment, which was left in a bowl of vinegar to disinfect it. The confectionery shop on the corner advertising Cadbury's chocolate was numbered as part of Upper High Street and was there until 1922.

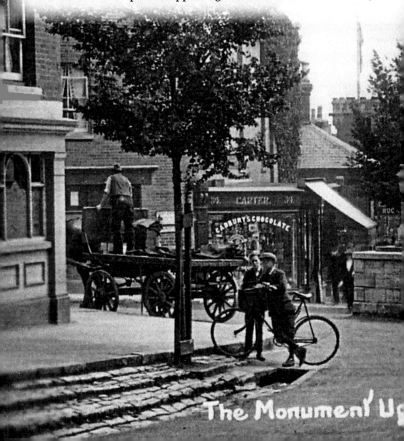

The Monument U

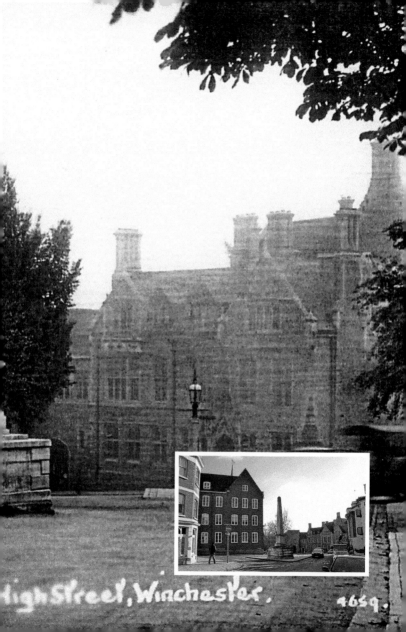

High Street, Winchester. 4659

22. WINCHESTER STATION

The London and South Western Railway (L&SWR) station dates from 1838, built by well-known railway architect Sir William Tite. A 1906 guidebook to Winchester shows that the office of Chaplin & Co. was in St Thomas Street and their depository in Hyde Street. In the same guidebook the L&SWR advertises the 'non-stop express corridor dining-car trains' that made the journey from London to Winchester in eighty-five minutes – not bad going considering today's fastest service is fifty-four minutes.

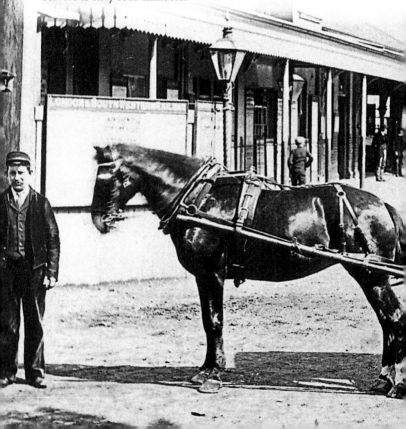

CHAPLIN & Cº CARRIERS.

AGENTS TO THE

LONDON & SOUTH WESTERN

& NORTH WESTERN RAILWAYS.

HOUSEHOLD REMOVALS.

CHAPLIN & Cº CARRIERS

23. THEATRE ROYAL

At the time of the inset photograph, around 1907, the Market Hotel was also the headquarters for the Cyclists Touring Club (CTC) and the National Cyclists Union (NCU) – see side of building. In 1914 it became a theatre, and then from 1920 a cinema, continuing as such until 1974. It was saved from demolition and purchased by the Winchester Theatre Fund, and with the aid of grants, trusts and fundraising, has undergone much renovation.

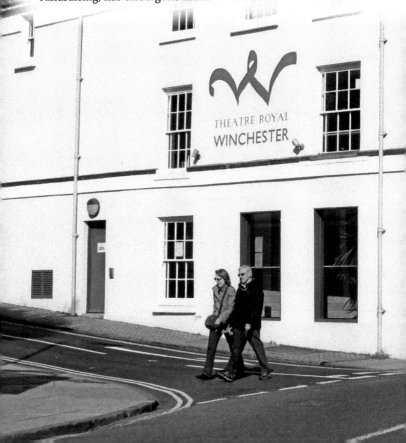

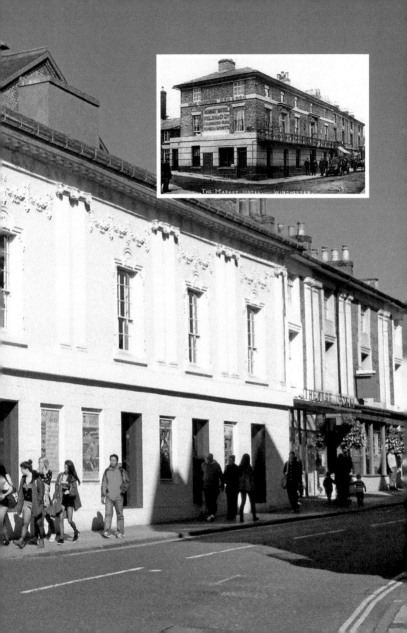

THE MARKET HOTEL, WINCHESTER.

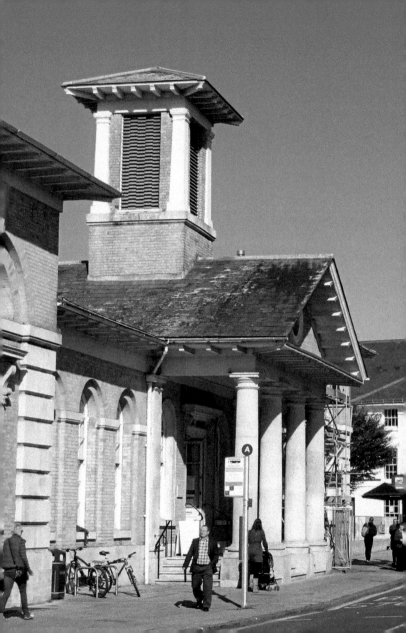

24. THE DISCOVERY CENTRE

The Corn Exchange was built in 1836–38 of yellow brick to the design of local architect Owen Carter. The Tuscan portico is believed to be modelled on that of St Paul's church in Covent Garden. At the time of the inset photograph it was the Regent cinema and restaurant; it opened as a library in 1936. When the building was recently refurbished, architects returned to Carter's original scheme and re-established the classical layout. It reopened as the **Discovery Centre** in 2007.

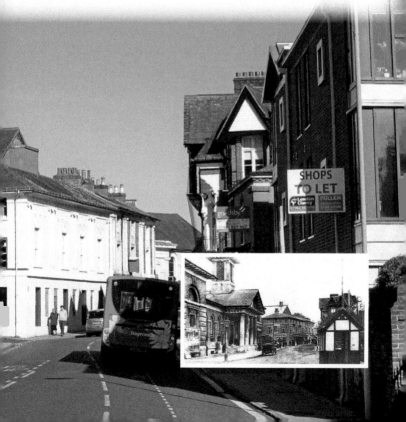

25. JEWRY STREET

The old gaol was first built in 1805 and used as a debtors' prison until 1849 when a new gaol opened on Romsey Road. The building became one of the first libraries in the country and at the time the inset photograph was taken, around 1916, it was occupied by Stopher's Ironmongers. It is now the Old Gaolhouse pub. The church next to it was built in 1853. On the other side at No. 11 was Rider's photographic studio, which is also now occupied by the pub.

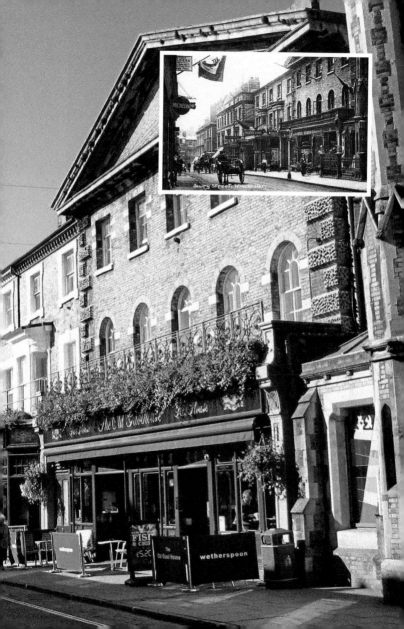

Jewry Street, Winchester

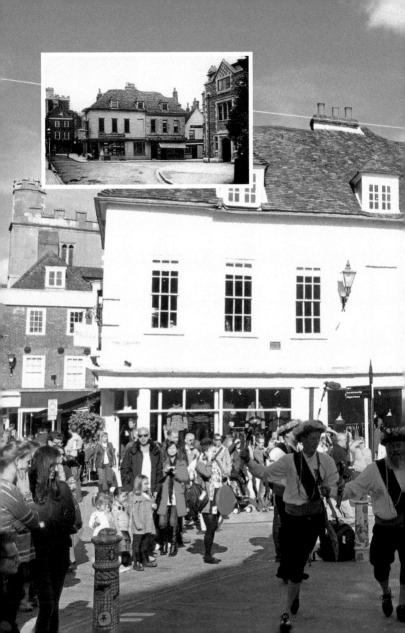

26. THE SQUARE

According to *Warren's Guide*, Magrath's bookshop was only in business between 1905 and 1906, and so dates the inset photograph. The City Museum opened in 1903, one of very few purpose-built museums outside London. The Eclipse Inn was so named because of the nearby Sun Inn. Its distinctive timber framing reappeared in the 1920s when the building was restored and the plaster covering was removed.

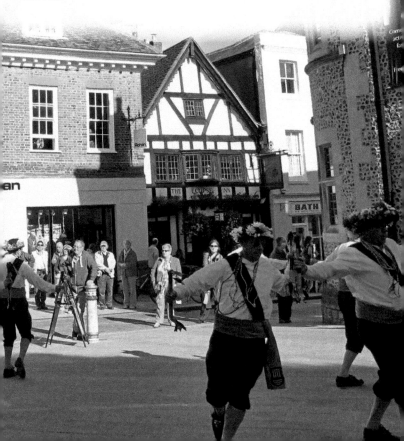

27. WINCHESTER CATHEDRAL

Founded in 1079, Winchester Cathedral is the longest medieval church in Europe. Over the years it has witnessed many historic events, including the second coronation of Richard I in 1194, the marriage of Queen Mary and Philip II of Spain, and the funeral and burial of Jane Austen. Today it attracts 300,000 visitors a year for its many tours, musical events and graduation ceremonies as well as its wealth of history.

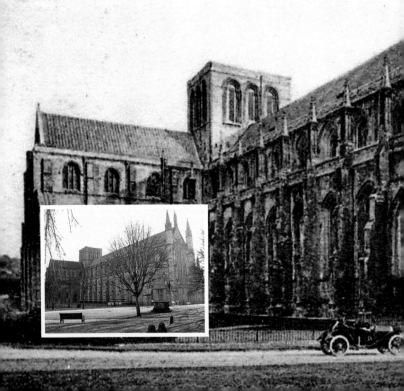

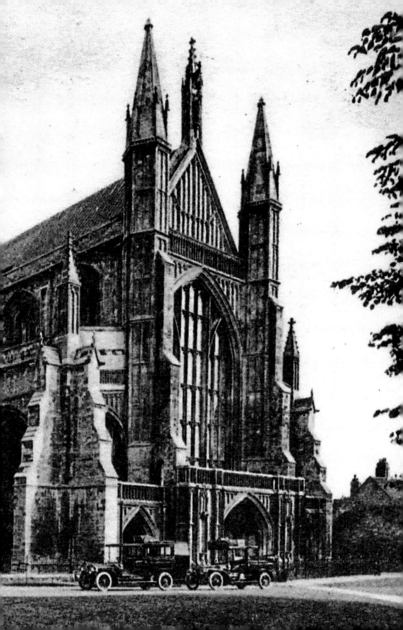

28. THE DEANERY

Tucked away in a corner of the Cathedral Close, the Deanery retains the peaceful atmosphere of a former monastery. Once the prior's lodgings it was substantially rebuilt in the seventeenth century, although the thirteenth-century vaulted porch still remains. This inviting piece of architecture now leads us into the Deanery's second-hand charity bookstall.

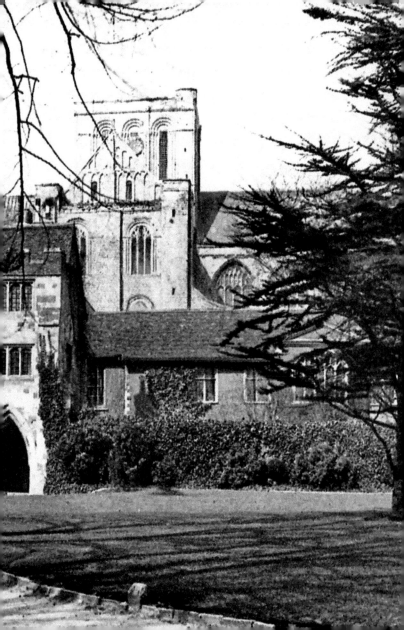

29. CHEYNEY COURT

Possibly the most photographed buildings in Winchester, after the cathedral, and ones that have changed the least, Cheyney Court is of the late sixteenth century. This was the site of the Court of the Bishops of Winchester in an area known as the Soke. The exit from the Cathedral Close is through Priory Gate, the nail-studded doors of which are locked at ten o'clock every night.

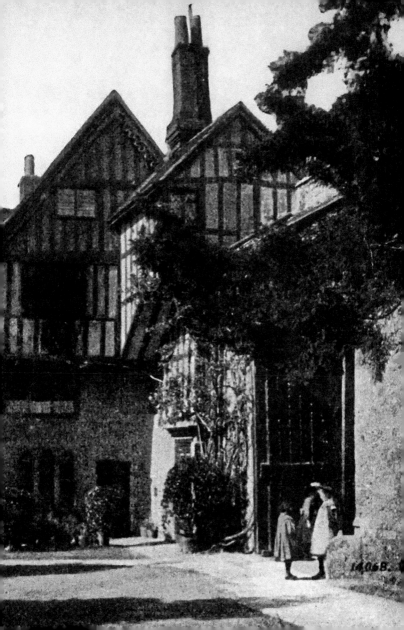

14068.

30. KING'S GATE

This is the second of the two medieval gateways still in existence in Winchester, and is quite possibly on the site of the original Roman south gate. Above it is housed the tiny chapel of St Swithun upon Kingsgate. The appeal of the area for period location settings has attracted film companies, and in 2012 a scene for the screen adaptation of *Les Misérables* was filmed under the archway.

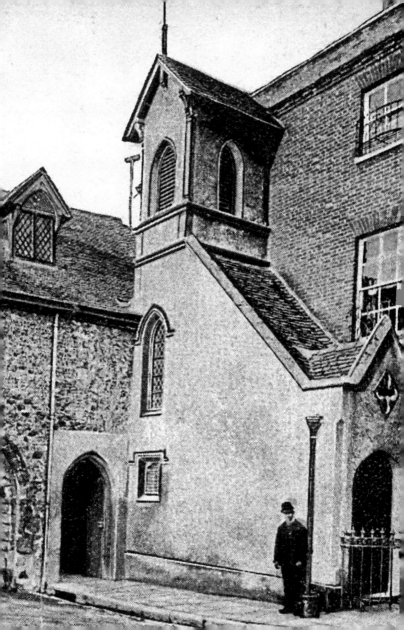

31. COLLEGE STREET

A destination for the literary tourist. In 1817, for the last few weeks of her life, Jane Austen lived at No. 8 College Street. It was here also that she wrote the poem 'Venta' about the people attending the annual Winchester races on St Swithun's day. Sixty years earlier John and Thomas Burdon began trading at No. 11; the earliest recorded receipt for 'stationery, books and binding' to the Bursars of Winchester College was in 1757. The bookshop became P&G Wells in 1891 and continues to serve the college and local community. The bindery still operates from the premises, now as a separate business.

Jane Austens House & Winchester

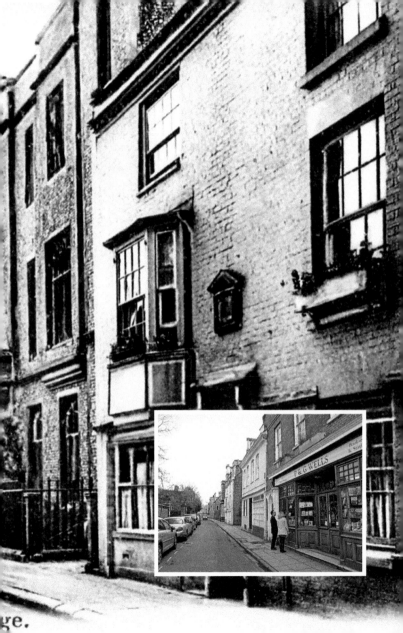

ge.

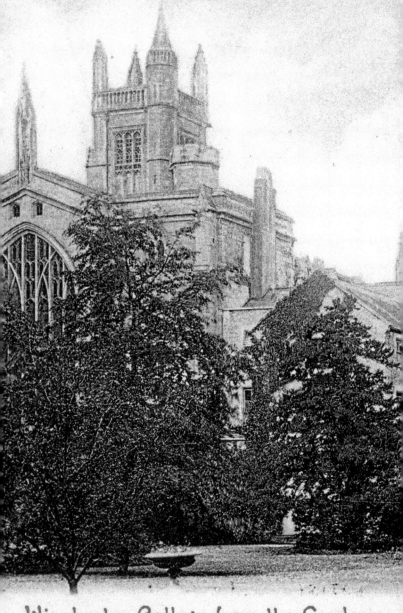

Winchester College from the Gardens

32. WINCHESTER COLLEGE

With the longest unbroken history of any school in England, Winchester College was founded in 1382 by William of Wykeham, Bishop of Winchester between 1366 and 1404 and twice Chancellor of England. Construction began in 1387, and when it opened in 1393 the Bishop's vision for the supply of educated men dedicated to God and the public service was realised. Buildings within the medieval heart of the college still to be admired are Chamber Court and the chapel which was consecrated in 1394.

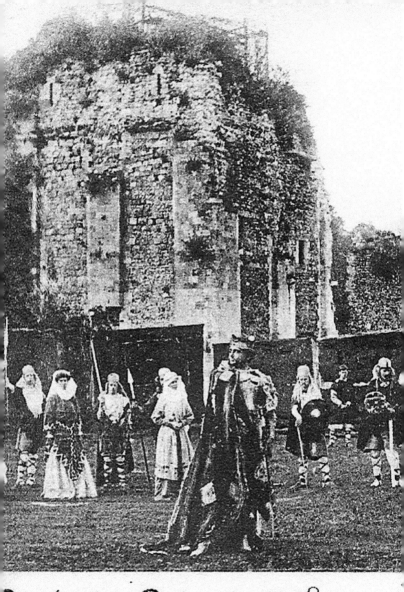

Winchester Pageant. 1908.

33. WOLVESEY CASTLE

Also known as the Old Bishop's Palace, this once grand residence was built by Bishop Henry de Blois in 1129, although it had been the site of the first Bishop's palace since the late 970s. In 1908 the grounds were chosen as the setting for the Winchester Pageant, an event held over five days to raise money for the cathedral which was in danger of collapsing. Music was composed specially and nine episodes were played out with characters from Winchester's history including Sir Walter Raleigh and Charles II. This scene depicts King Canute and Queen Emma.

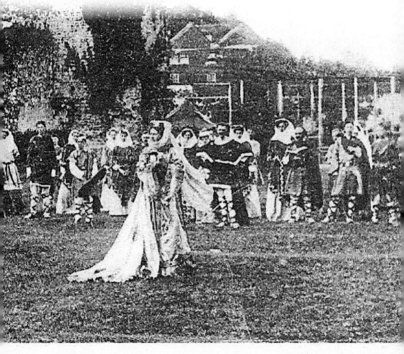

Gandy, Copy

34. WINCHESTER COLLEGE MEADS

Domum is from the Latin meaning 'homewards'; the theme in the college song is 'Dolce Domum'. It is recorded as being sung from 1768 in various locations around the college, and in 1835 in Meads, the playing fields south of the college. Winchester College football, also known as 'Our Game', is unique to the school; it is played with a soccer ball but includes a rugby-like scrum.

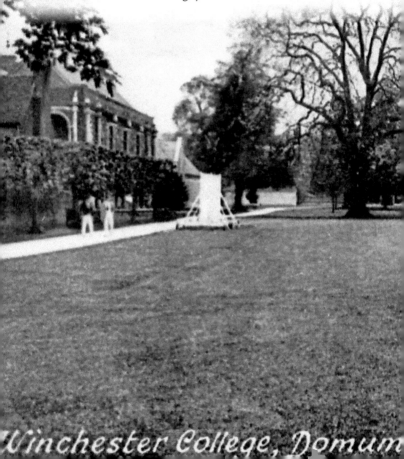

Winchester College, Domum

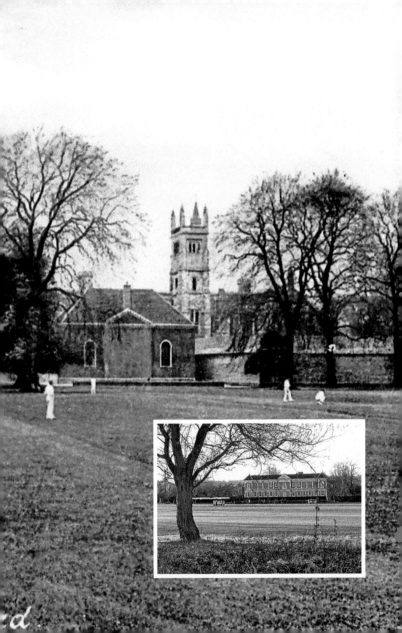

35. THE WATER MEADOWS

Just to the south of Winchester College, a complex of streams and channels of the Itchen Valley form the Water Meadows. They are said to be the source of inspiration for John Keats's 'Ode to Autumn' when he stayed here in the summer of 1819. Whether this is the case or not, we do know that he walked here and no doubt appreciated the beautiful scenery and views across the meadows to St Catherine's Hill.

The Meadow

G. O. Stuart, 1498

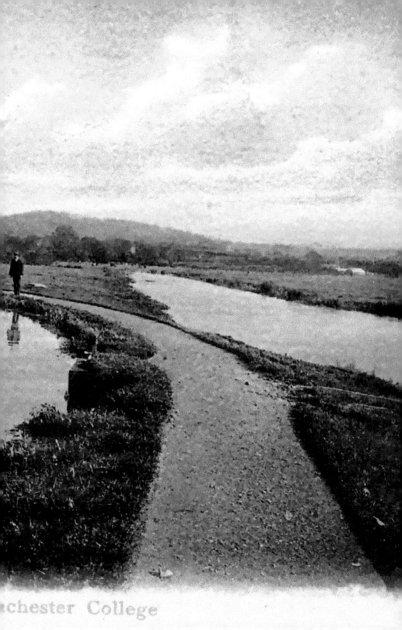

chester College

36. ST CATHERINE'S HILL

It is said that the beginnings of Winchester started here; indeed the excavated ditch still visible dates from the Iron Age. Until the nineteenth century a beacon stood ready to be lit in case of an invasion. The land is owned by Winchester College and the tradition of college boys using the hill as a playground goes back to the sixteenth century. Now a designated nature reserve, this flower-rich chalk grassland is managed by the Hampshire and Isle of Wight Wildlife Trust.

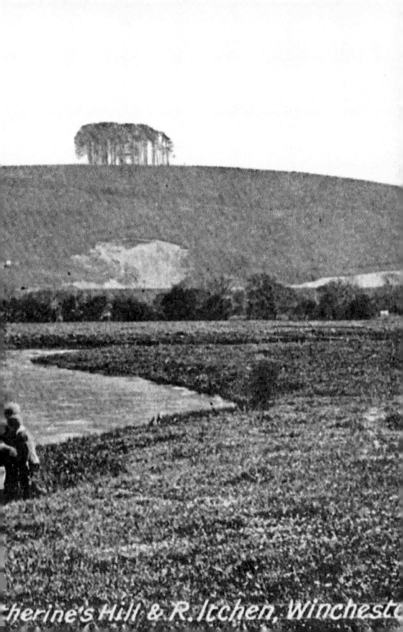

...herine's Hill & R. Itchen, Winchest...

37. ST CROSS HOSPITAL

Founded by Bishop de Blois in 1136 the hospital provided for thirteen gentlemen too frail to work, and fed another 100 at the gates each day. In 1446 the Almshouse of Noble Poverty was founded by Bishop Beaufort, for men of noble birth who had fallen on hard times. Today there are twenty-five brothers, who wear distinctive gowns. Visitors can view the church and several of the buildings, and enjoy both the Master's Gardens and in the summer months the Hundred Men's Hall tea room.

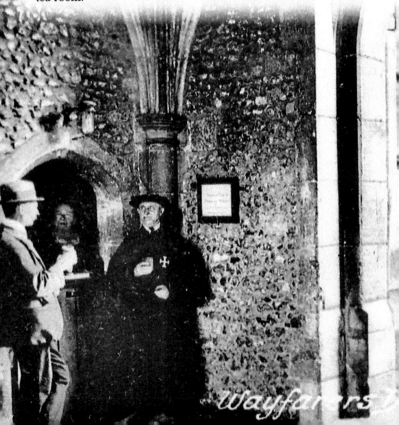

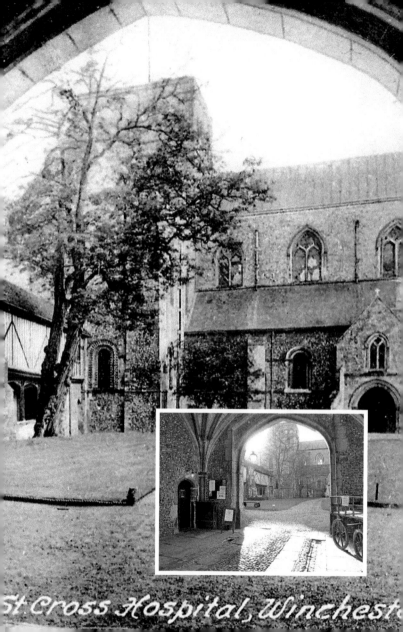

St Cross Hospital, Winchester

38. ST CROSS MILL

The earliest mill on this site belonged to the Hospital of St Cross; flour was ground for the brethren of the almshouses. It was rebuilt in 1843 and extended as a private house around 1900, just before this photograph was taken. The viewpoint here is from one of the bridges along Five Bridges Road, once the main road to Twyford via the Hockley junction before the motorway was built.

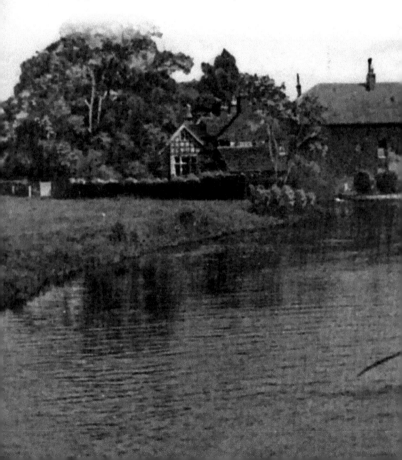

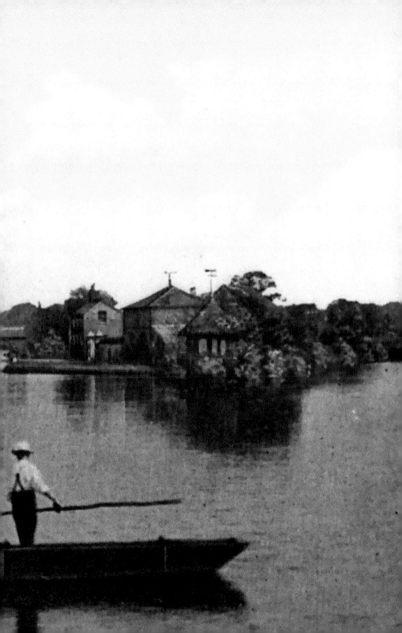

39. THE ITCHEN NAVIGATION

By 1869 the commercial traffic of barges had ceased but the towpath and waterway were enjoyed by Victorian walkers, swimmers and sailors, and Winchester College established a boat club at Wharf Bridge. The Itchen Navigation Heritage Trail Project, a five-year project which set out to improve this waterway for the benefit of walkers and wildlife, has recently been completed. This 10-mile stretch of the Itchen Way takes you from Wharf Bridge to Woodmill in Southampton.

ST. CATHERIN

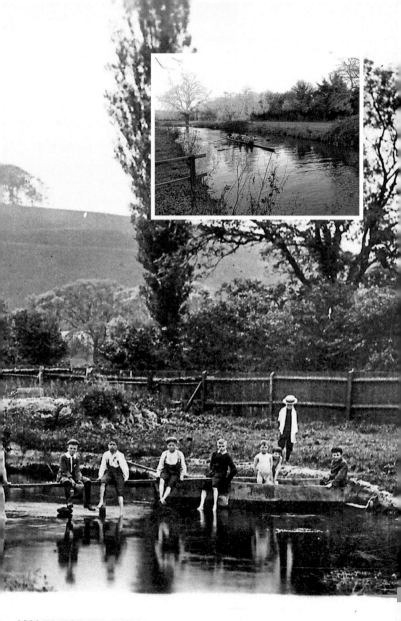

WINCHESTER

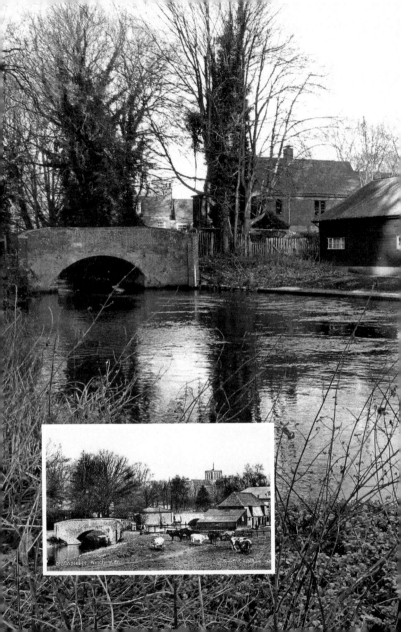

Blackbridge, Winchester

40. WHARF BRIDGE

At the foot of Wharf Hill is Black Bridge (the bridge in the inset photograph), a stone arch dating from 1796. This is the official head of the Itchen Navigation, a modification of the River Itchen, which was opened in 1710 to transport barges of coal and timber from Southampton to Winchester. In around 1900 (inset) the scene was very rural with the cows of Wharf Dairy grazing nearby

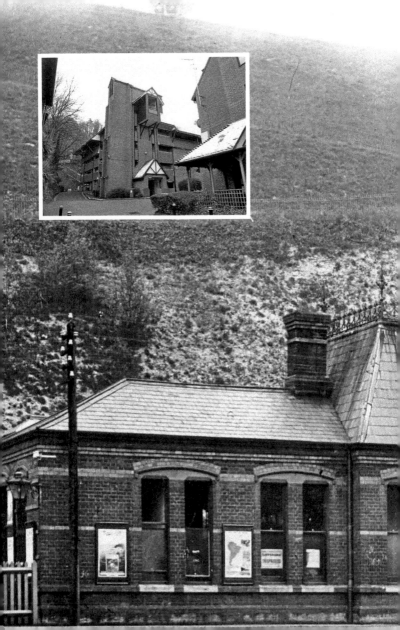

41. CHESIL CAR PARK (CHESIL STATION)

The first section of the Didcot, Newbury and Southampton (DN&S) line reached Winchester in 1885, the final stretch being a quarter-mile tunnel through St Giles Hill. The station was tucked to one side of Chesil Street, the only place where land could be purchased at a price the company could afford. Public services to Newbury commenced in the same year, with four trains each way on weekdays. Today Station Approach, next to the Chesil Rectory, is a pedestrian access to the former station yard, which is now offices and a multi-storey car park; both are developments of the 1980s.

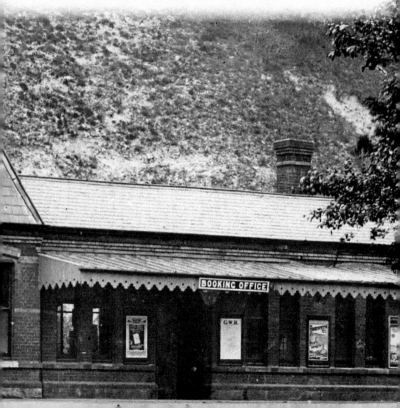

42. CHESIL STREET

Two shops once stood at the end of Chesil Street, but they were pulled down for the benefit of an early street-widening scheme. The Chesil Rectory was built by a wealthy merchant around 1450. Half-timbered, it is a remarkable survival of medieval Winchester when very few buildings were built of stone. It was restored in 1892 to 1893, and has been a tannery, antiques shop, tea room, general store and for the past fifty years, a restaurant.

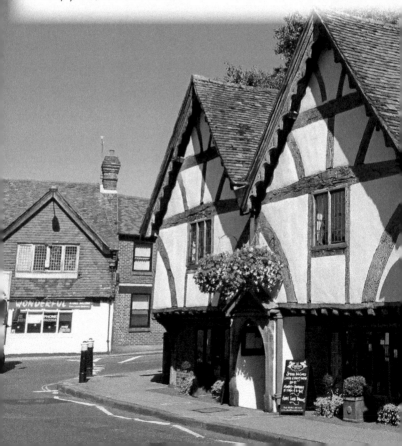

43. ST GILES HILL

This hill is the summit of a chalk spur which falls to the east bank of the River Itchen. In the late eleventh century, St Giles Fair was held here every September. The right to hold a fair was granted to Bishop Walkelin by William Rufus, and it was to last three days. It was extended to sixteen days in the reign of Henry I and drew merchants from all over the country and Europe. It is a steep walk up wooded pathways to the viewpoint, but well worth the climb.

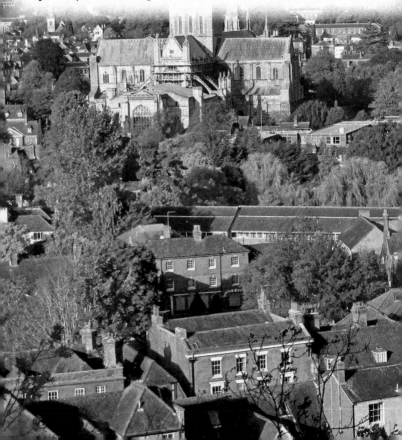

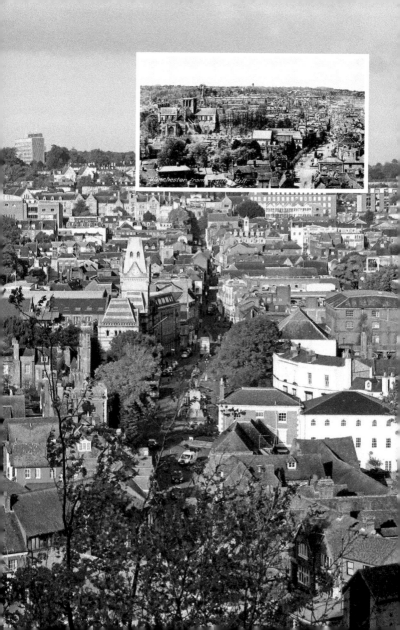

Winchester from Castle Hill

44. VIEW FROM CITY BRIDGE

St Swithun, the Anglo-Saxon Bishop of Winchester, was believed to have built the first bridge here over the Itchen in the ninth century. Legend tells of an act of kindness to a poor woman who was crossing the bridge carrying a basket of eggs when she was jostled and the eggs broke; the saint took pity on her and made them whole again. The bridge has been replaced many times; the present structure dates from 1813.

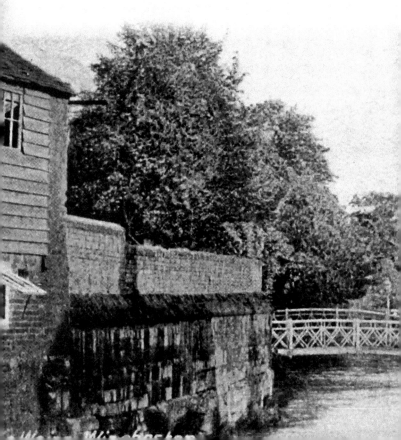